THE TAO OF MAGGIE

The Sound of One Hound Barking

BILL STANTON

**Andrews McMeel
Publishing**

Kansas City

To Ginny, who thought, forty-six years ago, that it would be
interesting to add a basset hound to the family mix.

To Sally, who found, ten years ago on an Ohio farm,
a frisky, pretty-faced pup we named Maggie.

And to Lola, who for eight years has watched her husband take
the oddest photos of "Margaret" while never giving the slightest
indication that it was anything but normal and fine.

THE TAO OF MAGGIE:
THE SOUND OF ONE HOUND BARKING

ISBN: 0-7407-3857-7

Library of Congress Control Number: 2003101260

03 04 05 06 07 WKT 10 9 8 7 6 5 4 3 2 1

"TO LIVE IS TO BREATHE."

—GEORGE SAND

"TO LIVE IS TO BREATHE
AND DROOL."

—MAGGIE

Drool is the sticky slobber of life. It is far more than just the drip that slowly moves from mouth to floor. And it is not just the by-product of a complex cooling mechanism that kicks into gear on a hot August afternoon. Drool, for me, is the symptom of a brain burning with keen anticipation. It is when we know what we want so badly that little glands in the mouth start to seriously overachieve. The brain churns and the body takes action.

Case in point: the out-of-reach box.

On the third shelf of an elevated kitchen cupboard sits an opened box of small dog treats. The box has been open for a day and the smells emanating from it have been driving me to distraction. I smell. I drool. I think. I take action . . . I weep.

I point my nose at the box behind the door and I produce a rhythmic low-level mournful yelp punctuated by my special ultrasonic weeping lament—a finely calculated combination of sounds that has been proven to get results time and again.

After a short while or a long while, a human comes and does the right thing—the cupboard door is opened, the treat withdrawn from the box and placed in my waiting mouth. It's the drooling that is the first manifestation of desire and the preface to action. If you are drooling, the blood is coursing through the body, the eyes are focused, the muscles are alerted, and the mind is following a plan of action with an iron will. To truly live is to drool.

Two thousand, six hundred or so years ago, the Chinese philosopher Lao-tzu wrote "All things come to those who wait." Waiting is part of the path taken by natural events. It is the always-changing yet eternal way to enlightenment—what Lao-tzu called the *tao*. As you can see from the above doggie-treat episode, I am a big believer in the power of waiting. But the waiting needs to be spiced with a proactive attitude.

My tao, the tao of Maggie, is closer to what Abe Lincoln wrote 140 years ago: "All things come to those who wait, but usually it's the leftovers from those who hustle."

It is my belief that all of those treats in the box would have eventually made their way to my moist mouth. They were, after all, bought for me—but if one waits effectively, they make their way mouthward sooner. And when treats are concerned, "Sooner is better than later." I think Joan of Arc said that.

As you may have noticed from the photos in this book, I have now reached the full blossom of my middle age. Most of my life is now as it should be. My domain spreads out from the gray couch where I spend long, lovely hours in mostly unconscious repose. My kibble is sautéed with the juice of a baked salmon—or on lean days extra-virgin olive oil (the first pressing, of course). The morning walk leads inevitably to Fahmi's Deli on the corner, where the whole-wheat bagel is waiting for my pickup. The naps are languid and luxurious and take place wherever I feel inclined. And now that the Stanton offspring has grown large enough to leave the pack, the entire backseat of the car is available to stretch out to my full grand length for those voyages to the leashless land of grass and deer poop.

But not all is sweet perfection. For life without a challenge is no fun to live. As Buddha said, "The obstacle is the way." Baths (an utterly mystifying waste of energy) are rare but still occur from time to time. And walks among the outdoor city smells are always too brief, even though I constantly strain the leash with my state-ments of resistance. And most troubling of all, out of the blue, two young cats recently arrived—and stayed. Of course, I was aghast. To make matters worse they took me to be some kind of great-aunt. Still, as Louis L'Amour, the author of all that cowboy

fiction, has said, "To exist is to adjust." And so I have. And I try to find the positive in a seemingly dreary situation. As things have settled down, the cats and I move in different circles. When our spaces overlap I assume a professional posture. I give voice and chase with a brief sprint. It is, I admit, a largely symbolic gesture, but it keeps the juices flowing. And, of course, the effort is rewarded with a nap in the sun and the reminder that even cats are part of the path of my life—the tao of me.

—MAGGIE

The art of patience

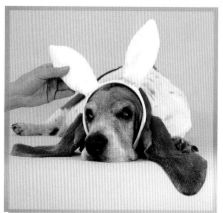 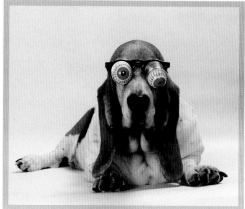

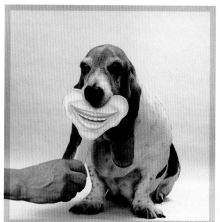 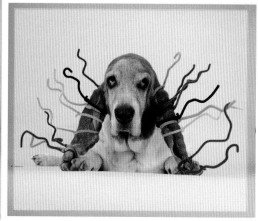

is the art of knowing what to overlook.

—HENRY JAMES

The voice so sweet, the words so fair,

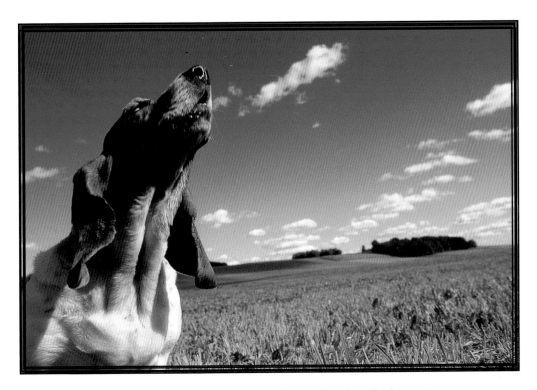

as some sweet chime has stroked the air.

—BEN JONSON

Accept what people offer.

Drink their milkshakes.

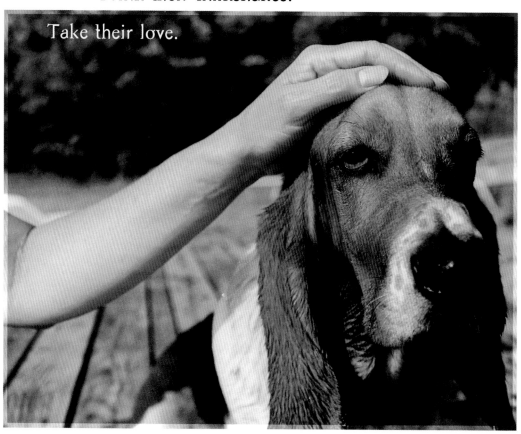

Take their love.

—WALLY LAMB

Until we lose ourselves,

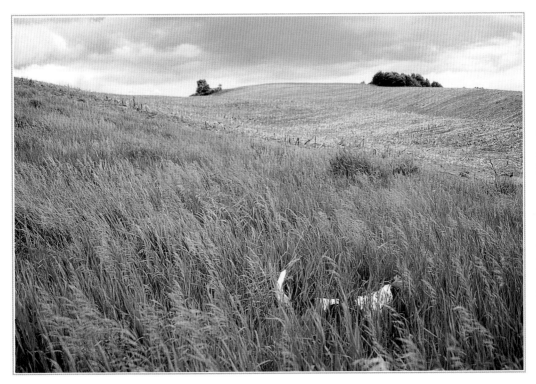

there is no hope of finding ourselves.

—HENRY MILLER

No snowflake ever f_al_l_s in the wrong place.

—ZEN PROVERB

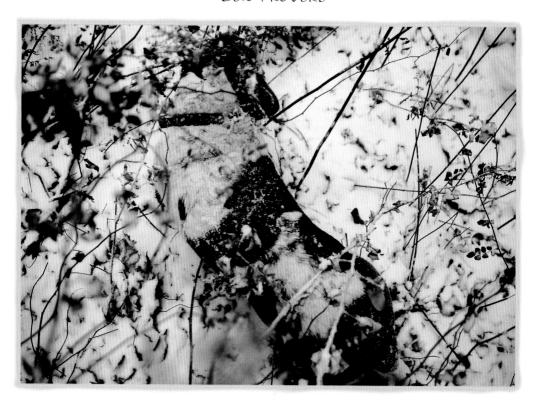

There is only **one** success.
To be able to spend your life
in **your own** way.

—Christopher Morley

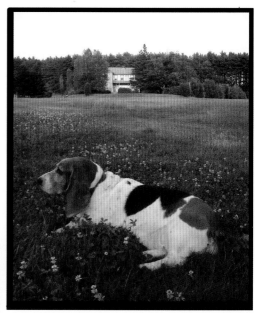

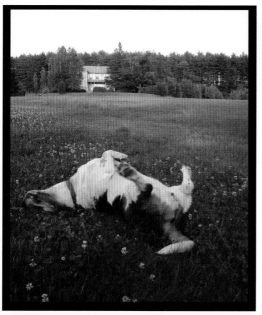

Right side up or upside down.

—Maggie

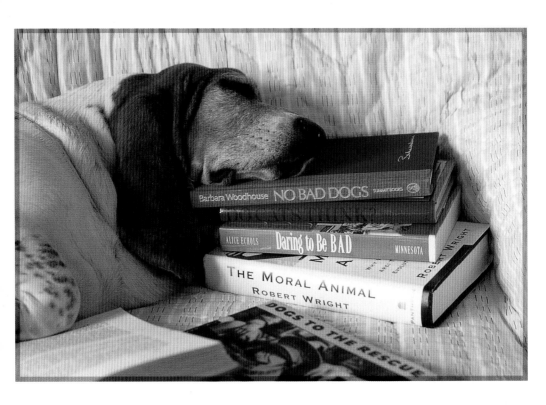

No time is ever wasted
if you have a book along as a companion.

—MARIAN WRIGHT EDELMAN

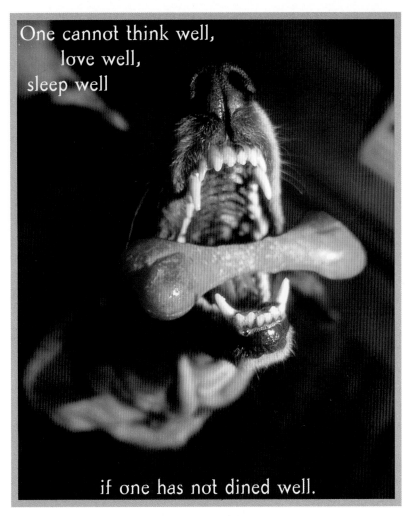

One cannot think well,
love well,
sleep well

if one has not dined well.

—Virginia Woolf

No matter how big or soft or warm your bed is,

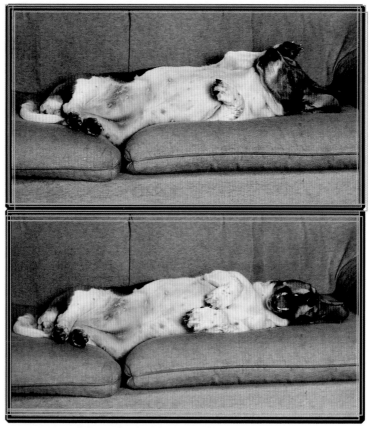

you still have to get out of it.

—GRACE SLICK

Enjoy the here and now;

the **delete** button could be pressed at **any** moment.

There is
no sincerer love
than the love of food.

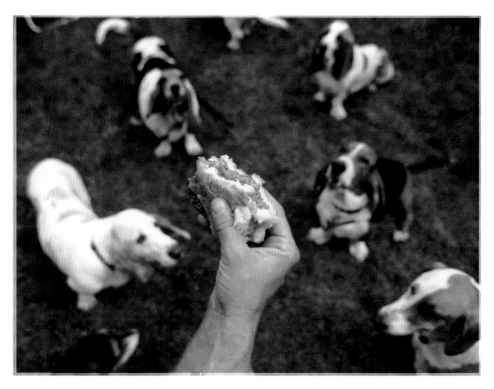

—GEORGE BERNARD SHAW

Fame is v a p o r .

—HORACE GREELEY

When the immovable object meets the irresistible force,

the force knows that the object will take a bribe.

Make waves.

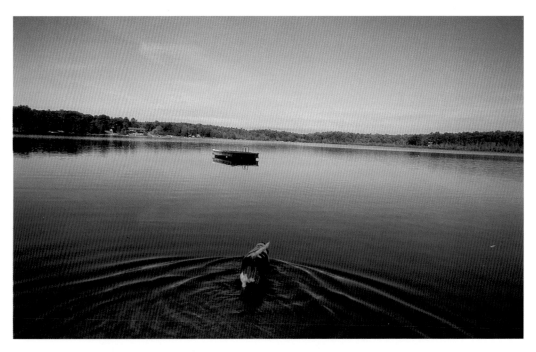

You never know what shores they reach.

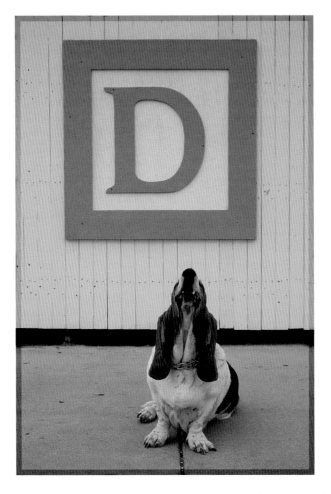

☐ D is for dog. ☐ D is for disgruntled.
☐ D is for diva. ☑ All of the above.

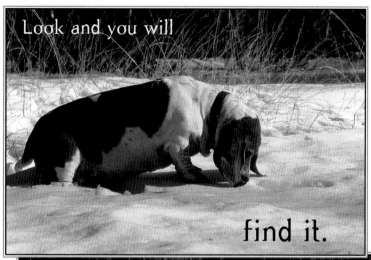

Look and you will

find it.

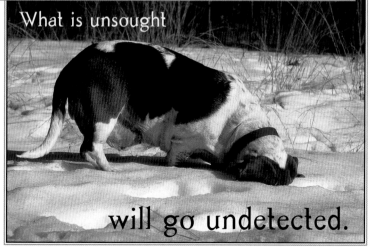

What is unsought

will go undetected.

—SOPHOCLES

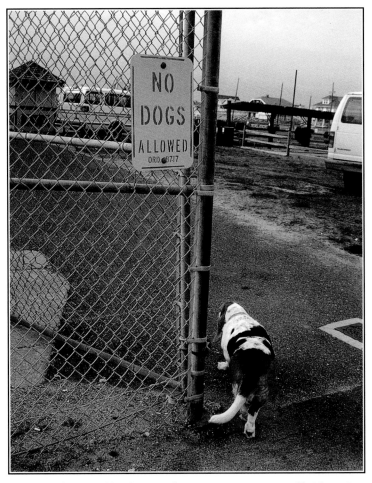

If you obey all the rules, you miss all the fun.

—KATHARINE HEPBURN

Fatigue is the best pillow.

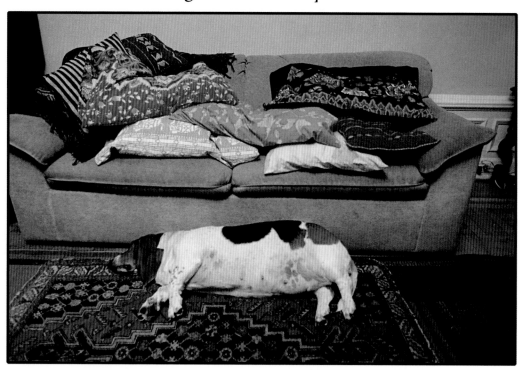

—BEN FRANKLIN

Blue sky, clean air,

and a cold wet nose to suck it in.

Winter is **best** appreciated from a leopard-skin lounge.

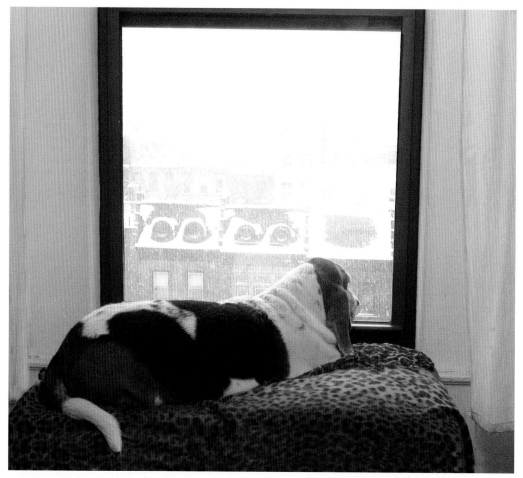

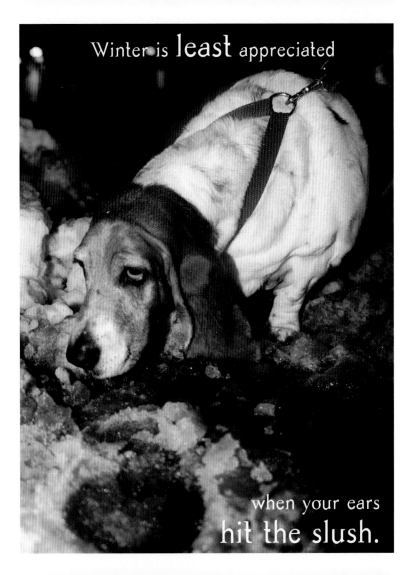

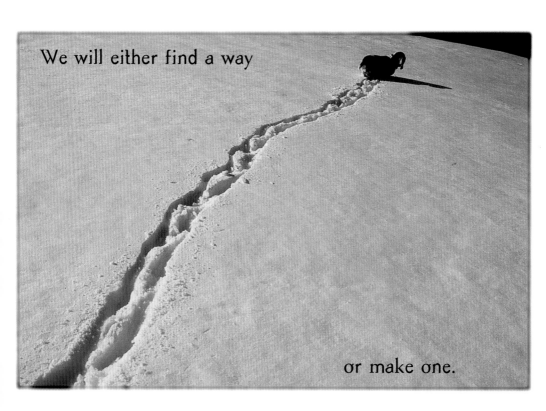

We will either find a way

or make one.

—HANNIBAL

To exist is to adapt.

—Louis L'Amour

To dream is happiness.

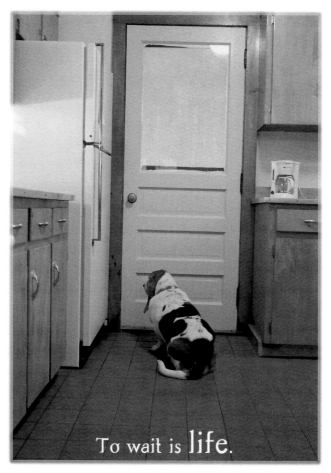

To wait is life.

—VICTOR HUGO

Cats are intended to teach us
that not everything in nature has a function.

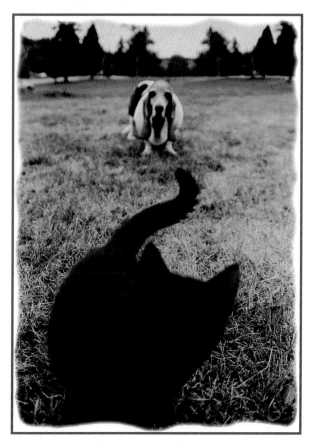

—GARRISON KEILLOR

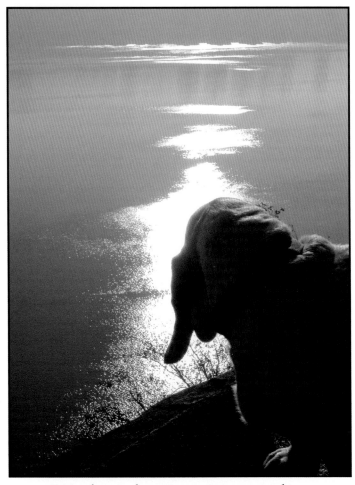

Wisdom begins in wonder.

—SOCRATES

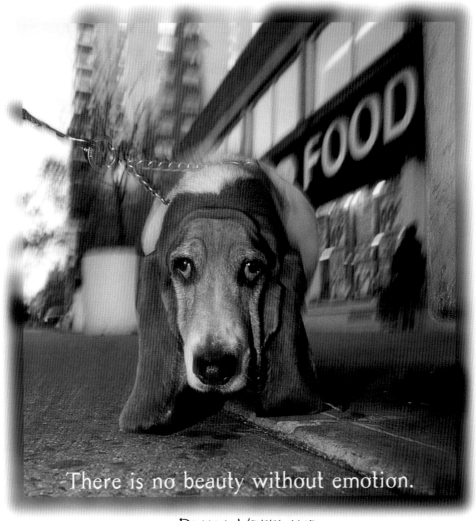

There is no beauty without emotion.

—DIANA VREELAND

To savor the heights, one must know the depths.

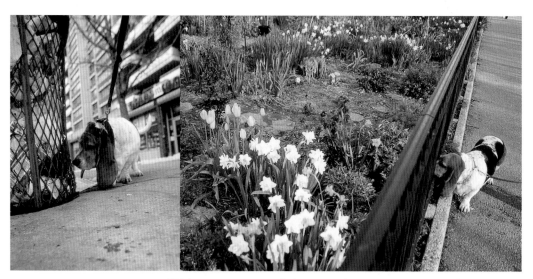

The question is
which is which?

The aim of life is to live—

joyously, drunkenly, serenely, divinely aware.

—HENRY MILLER

Sometimes you win. Sometimes you lose.

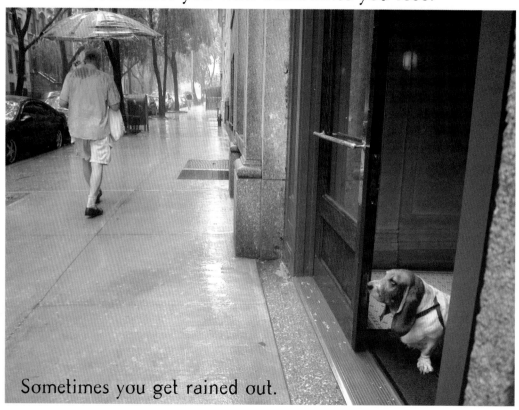

Sometimes you get rained out.

—SATCHEL PAIGE

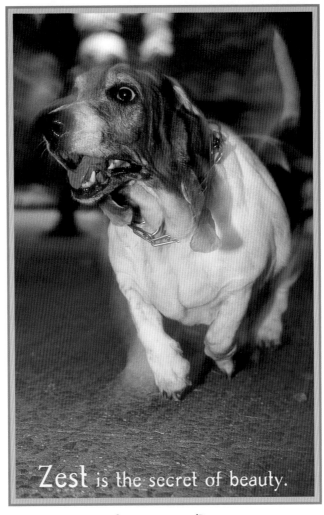

Zest is the secret of beauty.

—Christian Dior

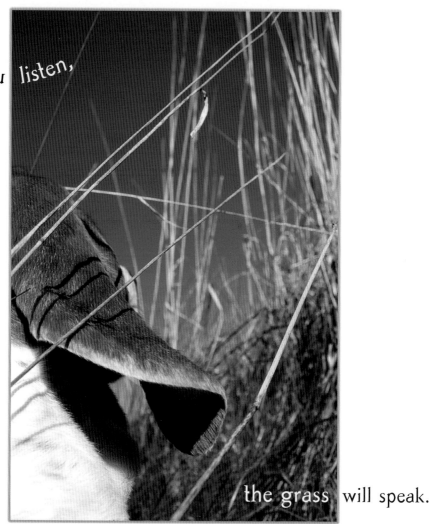

Pleasure is the object,

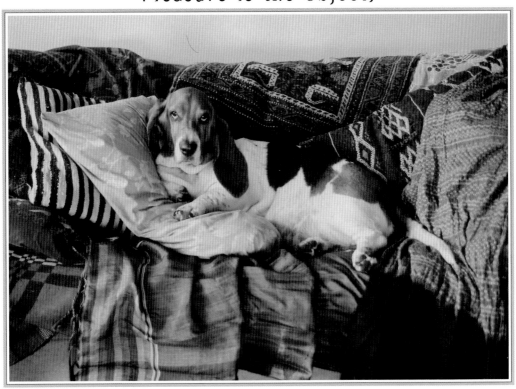

duty, and goal of all rational creatures.

—Voltaire

The head should be more
than a funnel to the stomach.

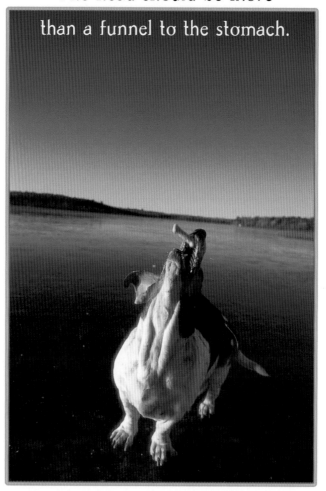

—GERMAN PROVERB

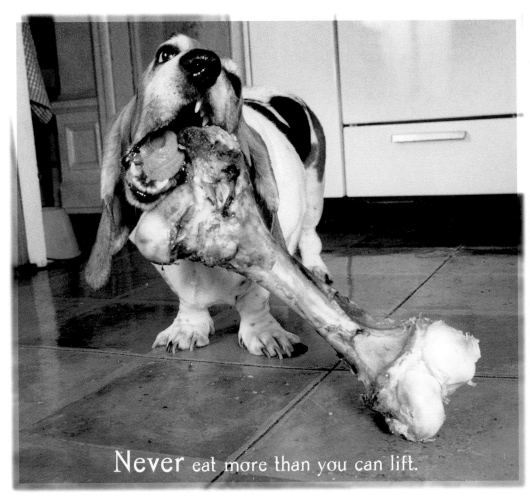

Never eat more than you can lift.

—Miss Piggy

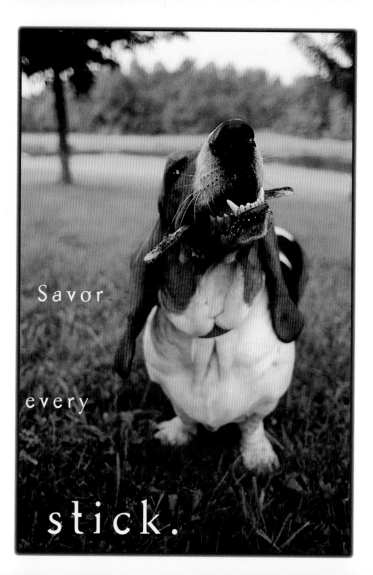

Savor

every

stick.

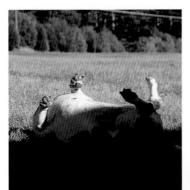
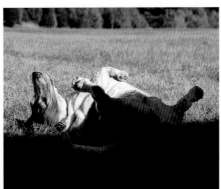

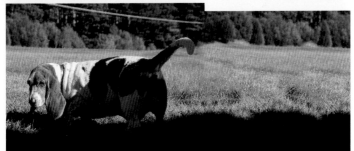

At least once a day let the bottom of your feet see the sun.

To go

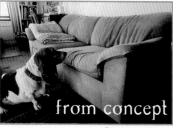

from concept

to

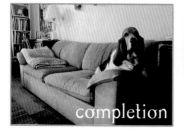

completion

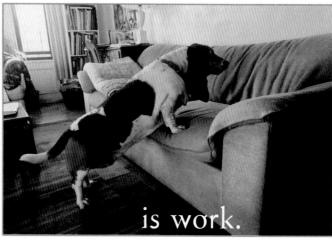

is work.

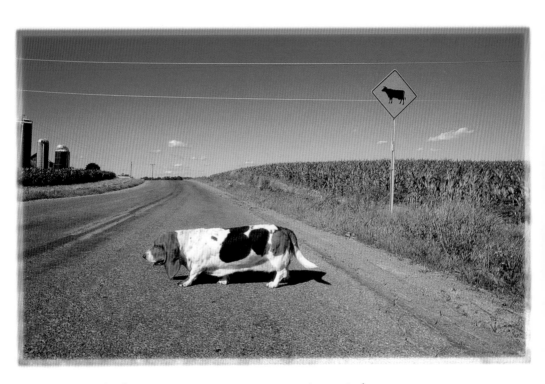

There are no coincidences.

What is essential

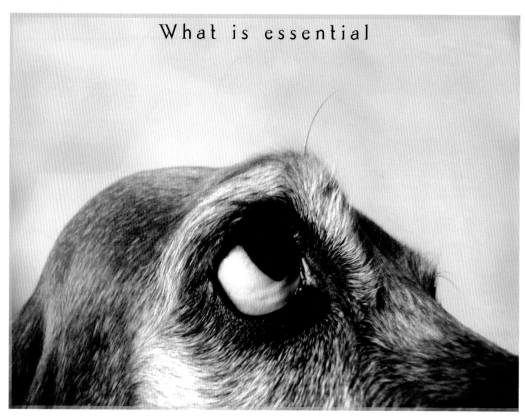

is invisible to the eye.

—FROM *THE LITTLE PRINCE* BY ANTOINE DE ST. EXUPÉRY

Find the softest place

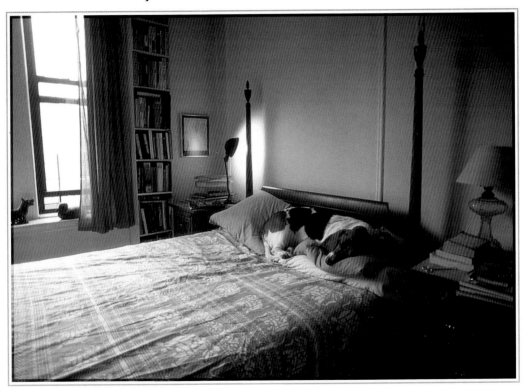

and stay forever.

Conscience is that inner voice that **warns** us that someone may be looking.

—H. L. MENCKEN

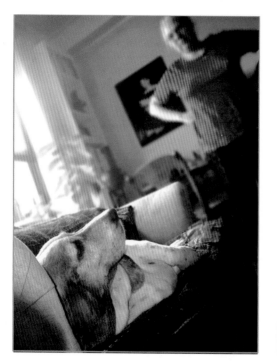

Such a small and distant voice can be ignored.

—MAGGIE

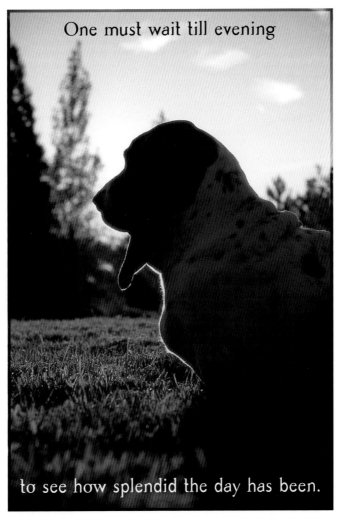

One must wait till evening

to see how splendid the day has been.

—SOPHOCLES

So much to do.

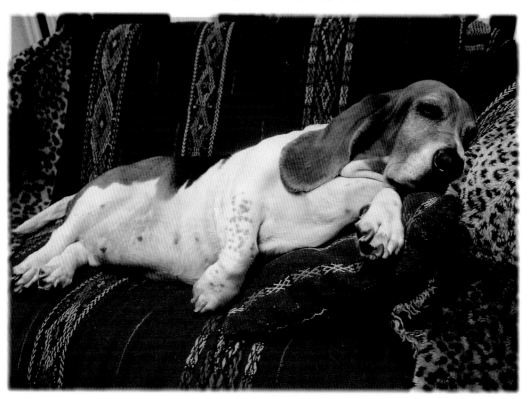

So little time.

—Napoleon Bonaparte

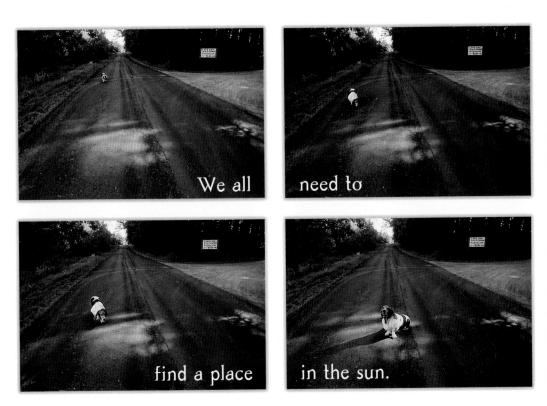

We all need to find a place in the sun.

The root of success

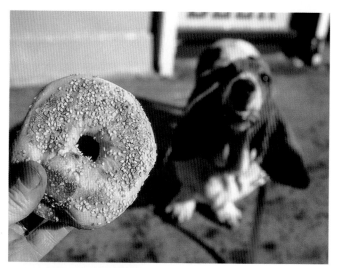

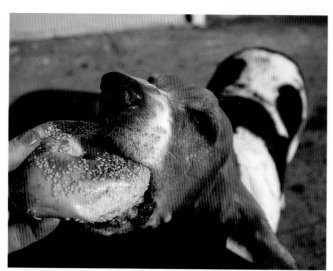

is simply
to follow through.

—SAMUEL JOHNSON

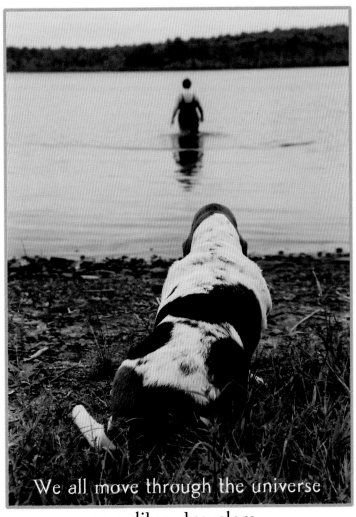

We all move through the universe

as solitary travelers.

A woman's legs are her foundation.

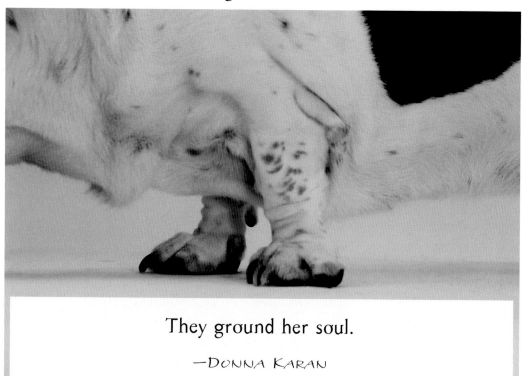

They ground her soul.

—DONNA KARAN

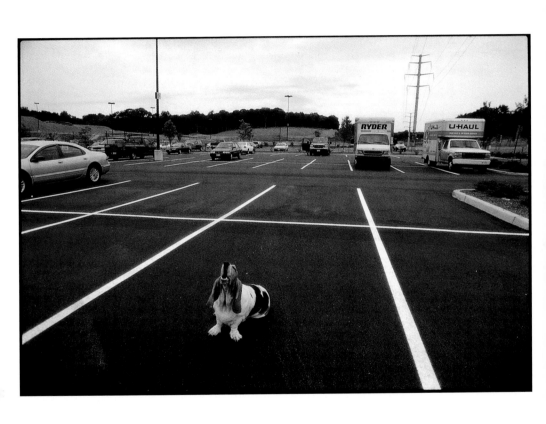

Barking space.

I loaf and invite my soul.

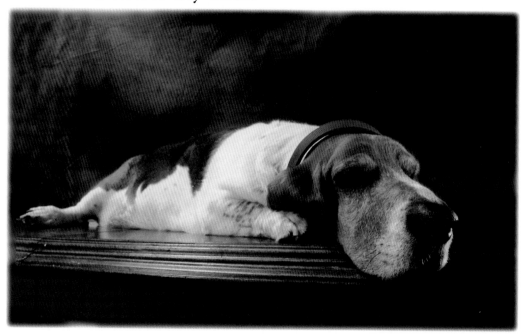

—WALT WHITMAN

A leg bends. An ear flops.
A body moves. A chain restrains.

Only those who risk going too far

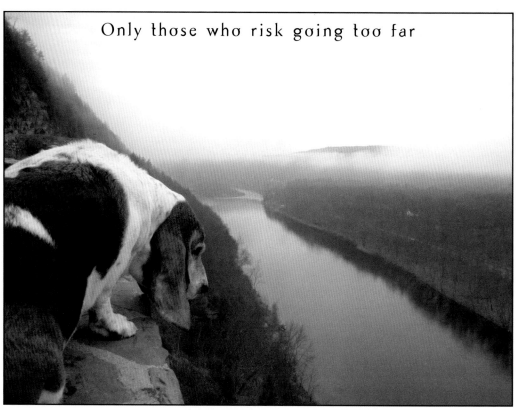

can possibly find out how far one can go.

—T. S. ELIOT

When questions about social graces arise,
just be yourself

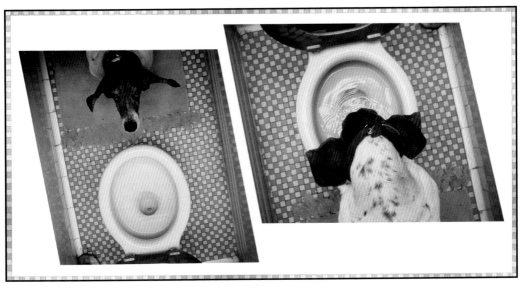

(and if possible, keep your ears dry).

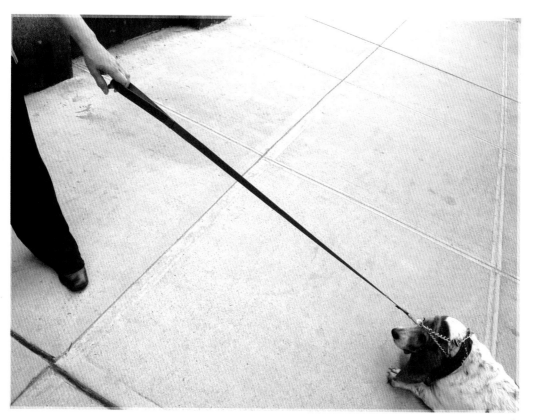

It's my way or it's no way.

Common sense tells us that our existence is

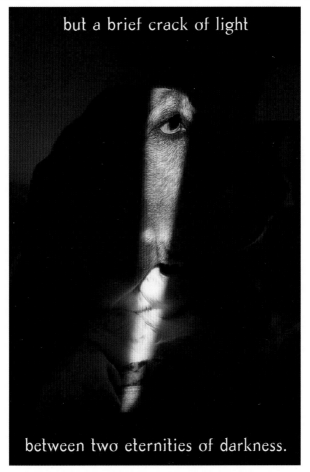

but a brief crack of light

between two eternities of darkness.

—VLADIMIR NABOKOV

Despite **certain** physical disadvantages (such as three-inch legs),

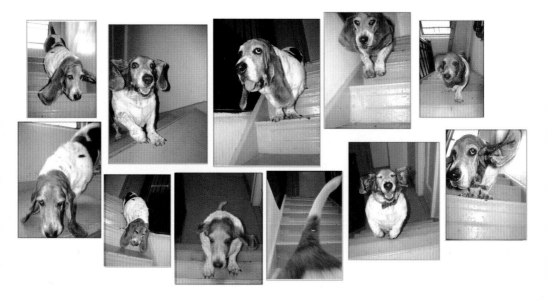

one does what one **has** to when the elevator has broken down.

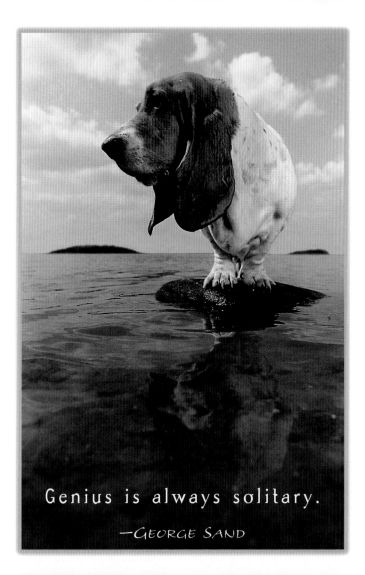

Genius is always solitary.

—GEORGE SAND

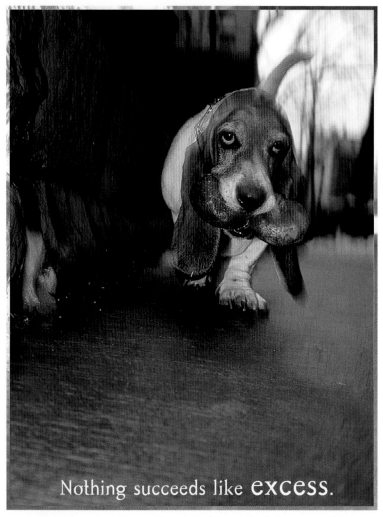

Nothing succeeds like **excess**.

—OSCAR WILDE

Quietly and quickly exit any body of water

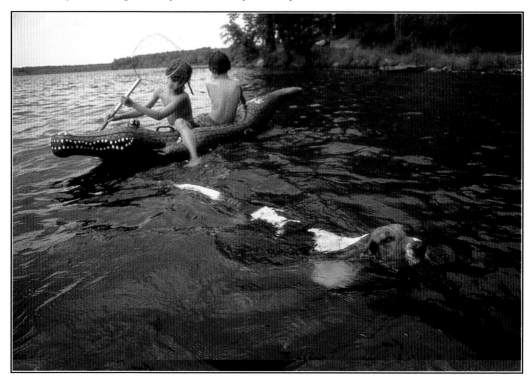

containing crocodiles ridden by children.

The Earth does not belong to us.

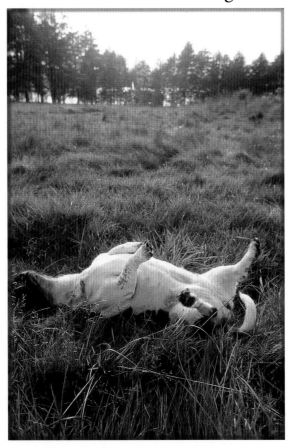

We belong to the Earth.

—CHIEF SEATTLE

The nice thing about meditation

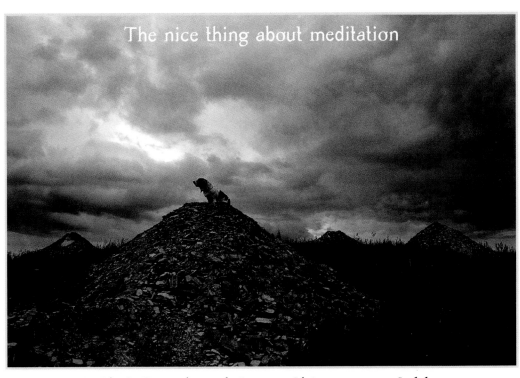

is that it makes doing nothing respectable.

—PAUL DEAN

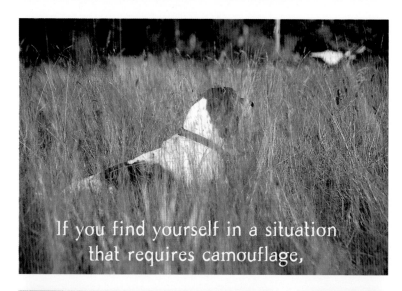

If you find yourself in a situation that requires camouflage,

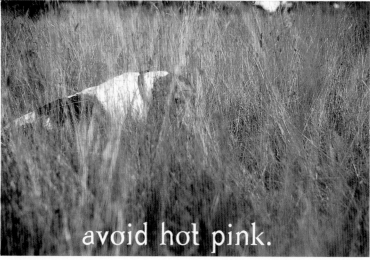

avoid hot pink.

The most beautiful thing we can experience

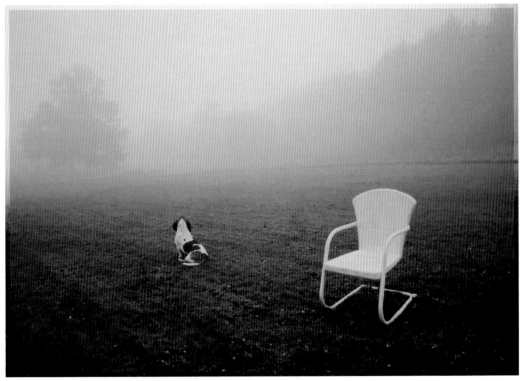

is the mysterious.

—ALBERT EINSTEIN

One generation plants the tree;

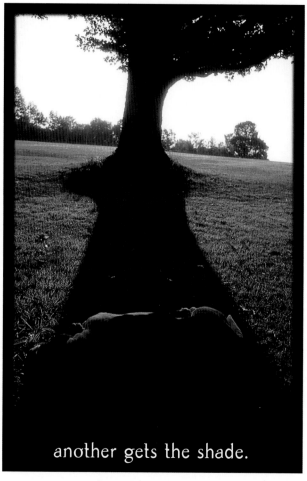

another gets the shade.

—CHINESE PROVERB

The body is shaped, disciplined, honed, and, in time,

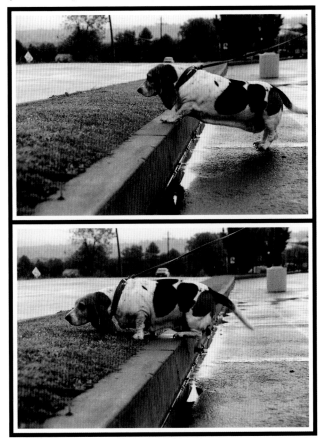

trusted.

—MARTHA GRAHAM

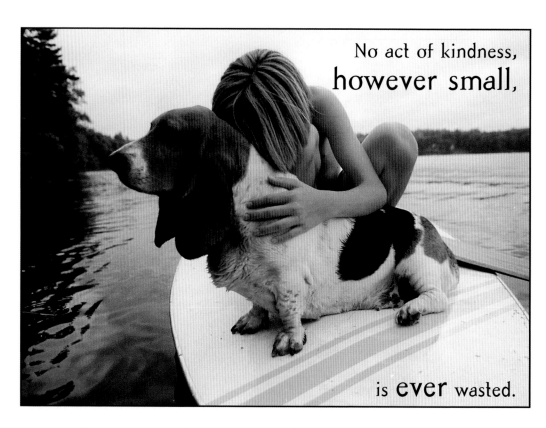

No act of kindness, **however small**, is **ever** wasted.

—FROM AESOP'S FABLE "THE LION AND THE MOUSE"

As one goes through life,

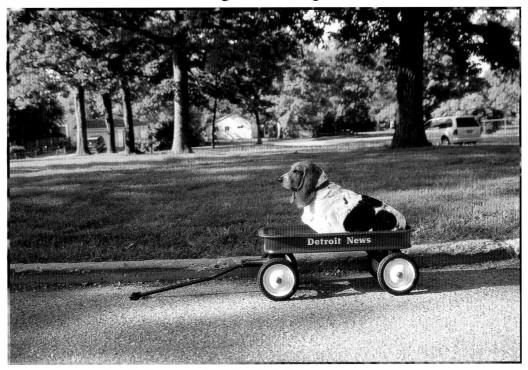

one learns that if you don't paddle your own canoe,
you don't move.

—KATHARINE HEPBURN

Maturity of mind
is the **capacity**

to endure
uncertainty.

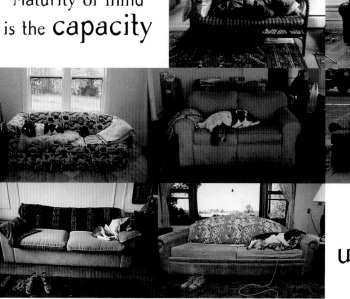

—JOHN FINELY

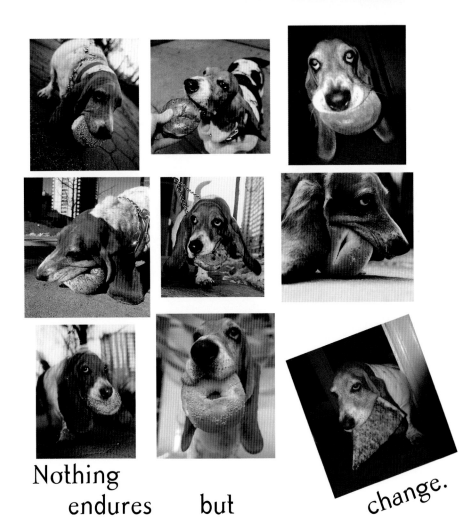

Nothing
endures but change.

—HERODOTUS

Earth is **crammed** with heaven.

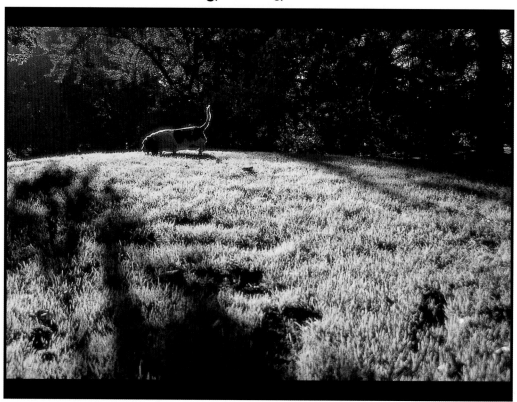

—ELIZABETH BARRETT BROWNING

To **live** is to breathe.

—GEORGE SAND

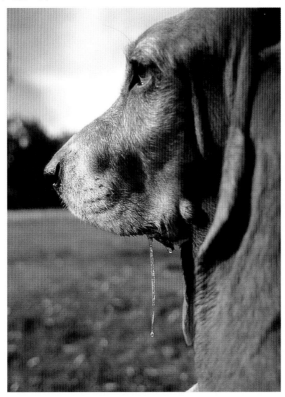

To live is to breathe and **drool**.

—MAGGIE

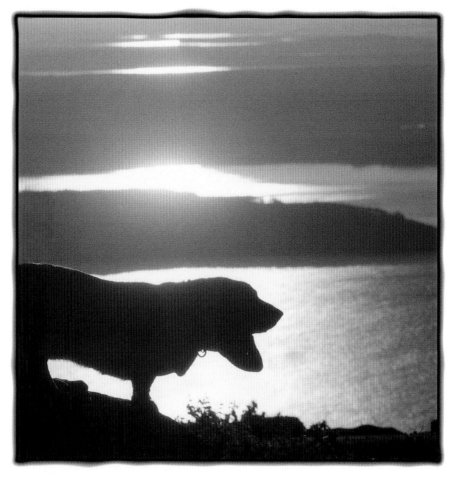

Only the day dawns to which we are awake.

—HENRY DAVID THOREAU

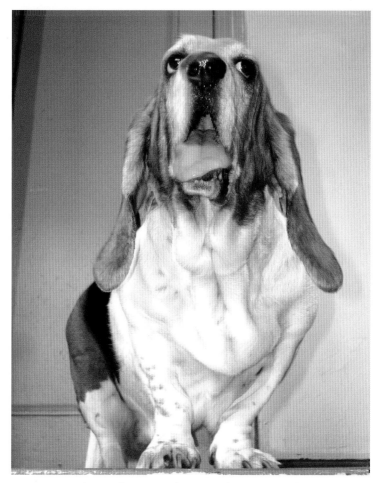

A closed mouth catches no flies.

—FRENCH PROVERB

Whether

we

hear

it

or

not,

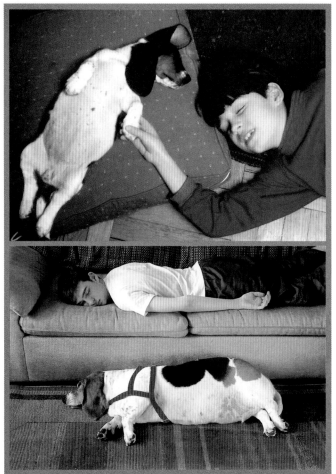

the

clock

still

ticks.

Autumn is a second spring

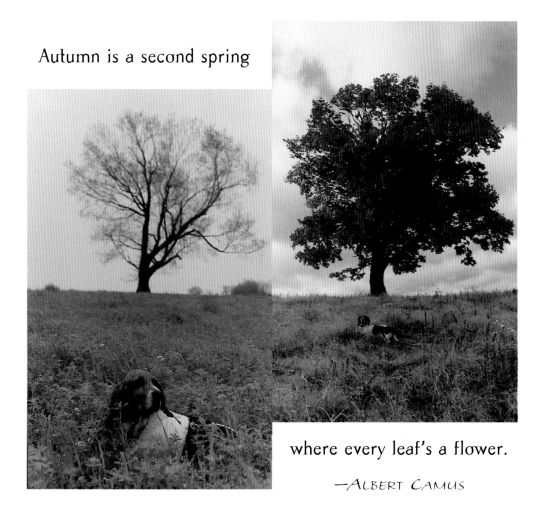

where every leaf's a flower.

—ALBERT CAMUS

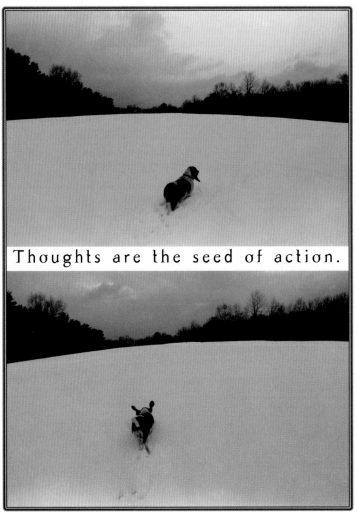

Thoughts are the seed of action.

—RALPH WALDO EMERSON

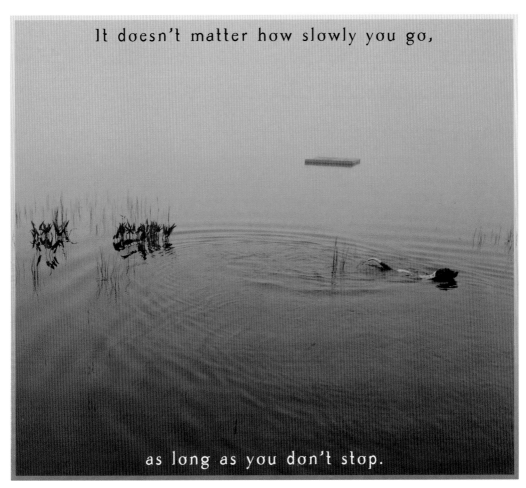

It doesn't matter how slowly you go,

as long as you don't stop.

—CONFUCIUS

When force is necessary,

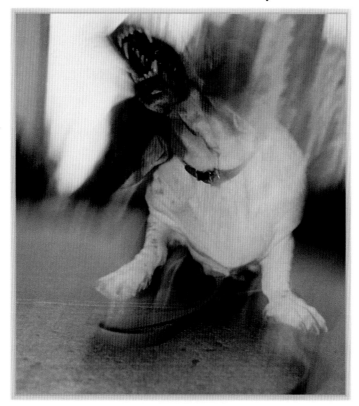

it must be applied **boldly**, decisively,
and c o m p l e t e l y .

—LEON TROTSKY

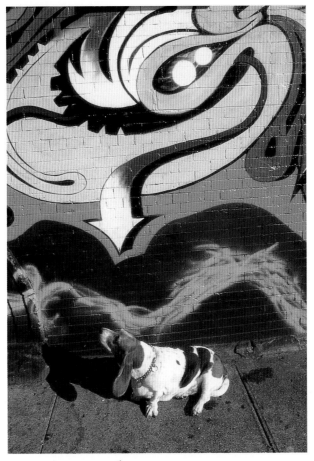

Art happens.

—JAMES ABBOTT MCNEIL WHISTLER

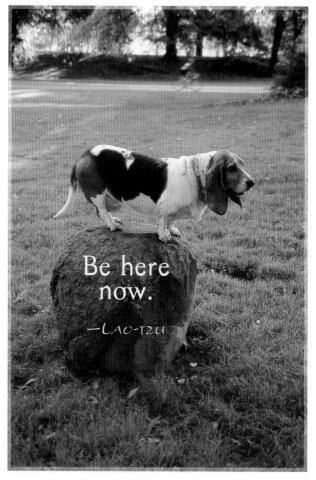

I am. Now what?

—MAGGIE

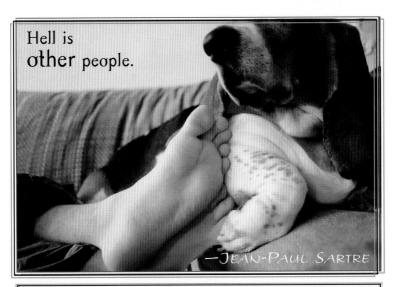

Hell is **other** people.

—JEAN-PAUL SARTRE

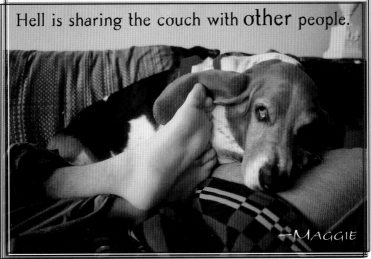

Hell is sharing the couch with **other** people.

—MAGGIE

Disregard petty diversions.

Follow your nose.

What is before our nose

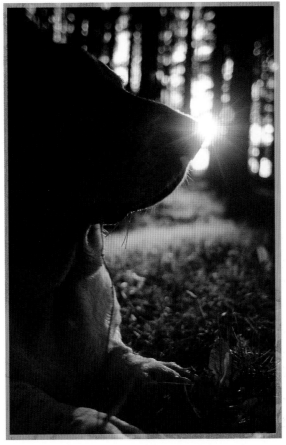

is what we see last.

—WILLIAM BARRETT

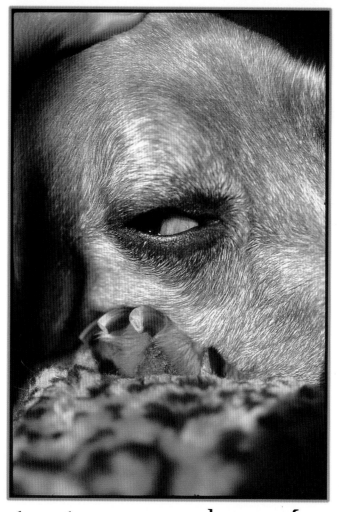

Don't l o o k at me in that **tone of voice.**

Avoid dragging nipples

through the snow.

Hors d'oeuvres are anywhere you find them.

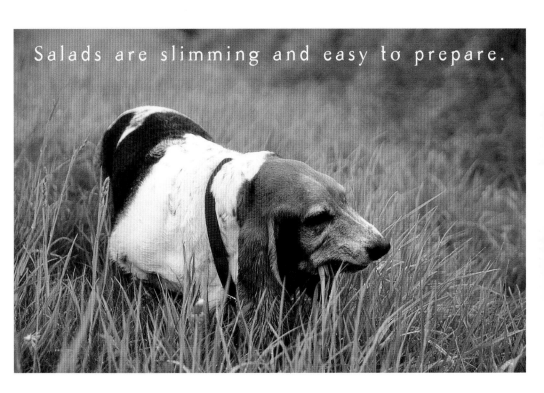
Salads are slimming and easy to prepare.

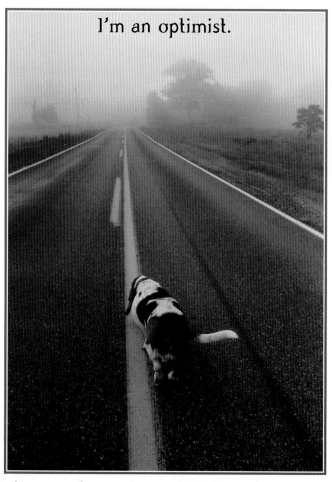

I don't know where I'm going but I'm on my way.

—CARL SANDBURG

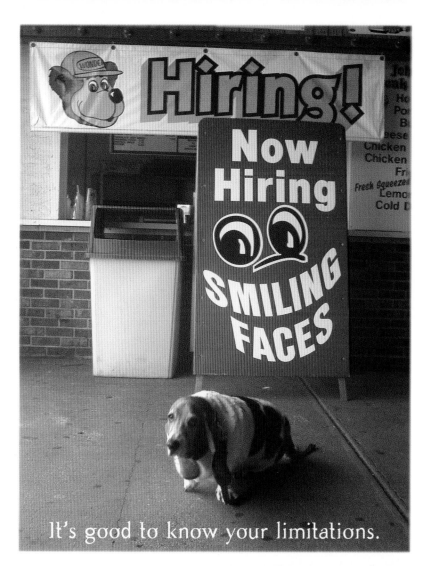

It's good to know your limitations.

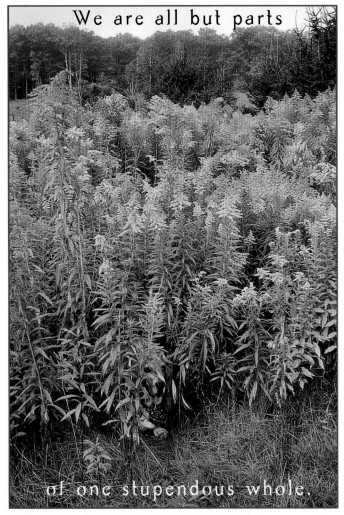

We are all but parts

of one stupendous whole.

—ALEXANDER POPE

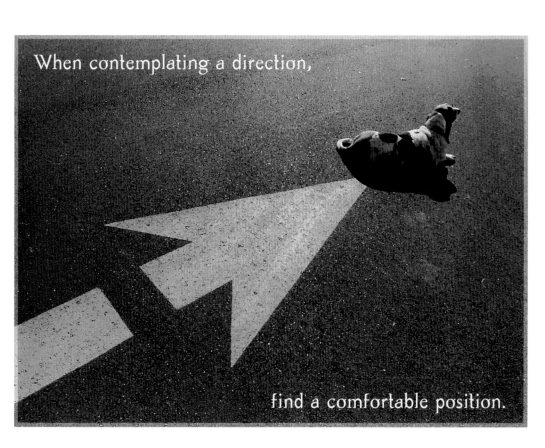

When contemplating a direction,

find a comfortable position.

Never look back; there might be something gaining on you.

—SATCHEL PAIGE

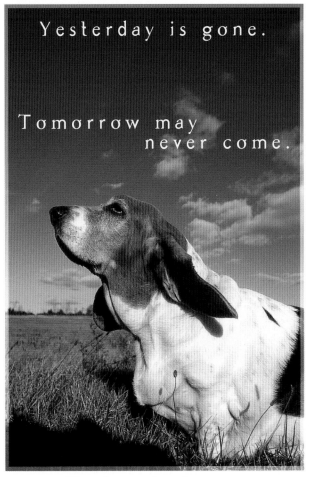

Yesterday is gone.

Tomorrow may
never come.

Today is here.

—CARL SANDBURG

It is difficult to maintain serenity in a chaotic world.

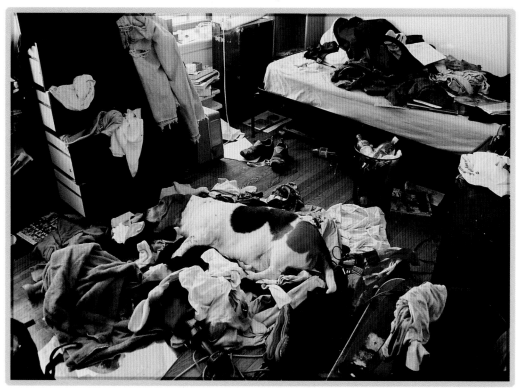

Still one must try.

A little nonsense now and then
is relished by the wisest.

—ROALD DAHL

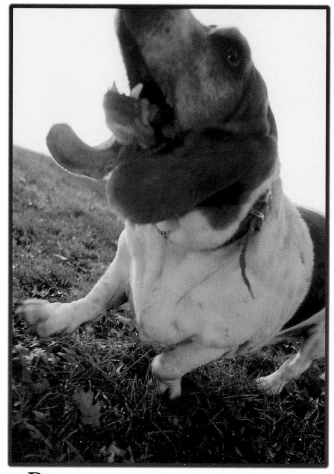

Dance like no one is watching.

—SATCHEL PAIGE

The way of progress

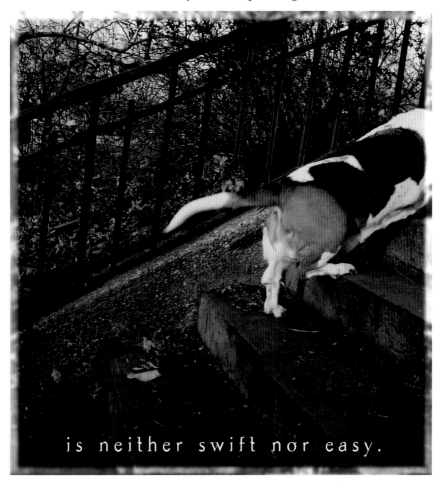

is neither swift nor easy.

—MARIE CURIE

It takes two to speak the truth.

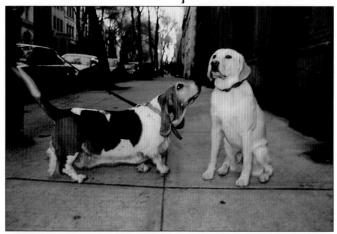

One to speak

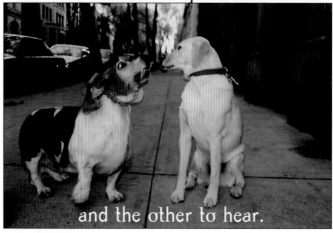

and the other to hear.

—HENRY DAVID THOREAU

If you're going through hell,

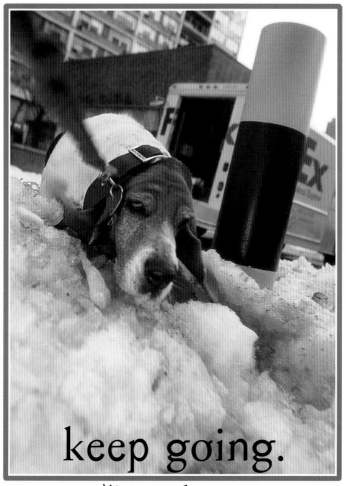

keep going.

—WINSTON CHURCHILL

Among the many advantages of nudity,

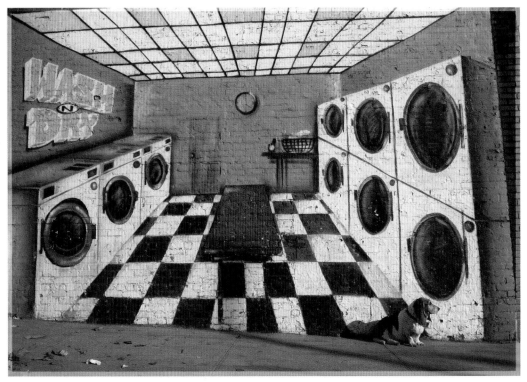

laundromats become irrelevant.

There must be
more to life than

**having
everything.**

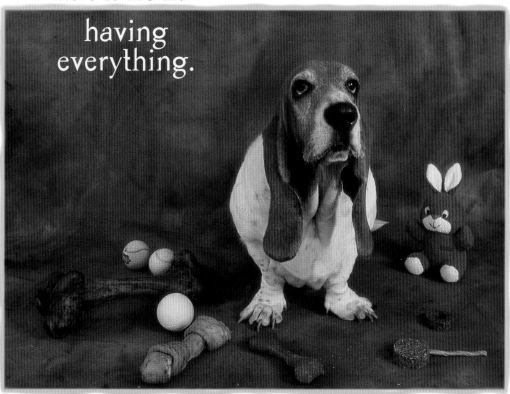

—Maurice Sendak

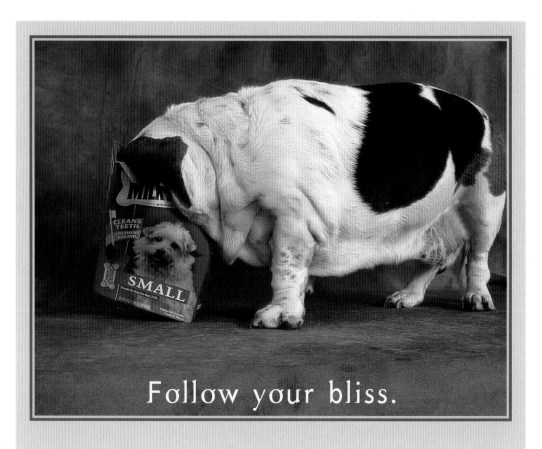

Follow your bliss.

—JAMES CAMPBELL

One more such victory

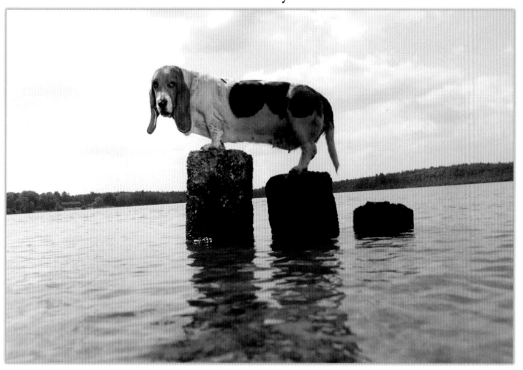

and we are lost.

—PYRRHUS

The only solution is to remain in bed all day.

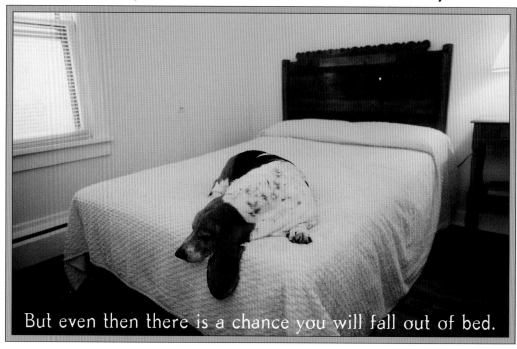

But even then there is a chance you will fall out of bed.

—Robert Benchley

I'll chance it.

—Maggie